All the Living Things

All the phenomena of the world are information.

Mankind made words and pictures

to navigate this matter.

So we think we know.

Jim Holl

Verve

Inspiration for this project came to me as I viewed a Matisse exhibition, in 2014, at the Museum of Modern Art. The show included excerpts from *Verve*, an art and literature magazine published in Paris between 1937 and 1960 by Tériade (Stratis Eleftheriades). Images for the magazine were created by Matisse, Picasso, and other art luminaries of the time. Tériade's initiative was an independent art and literature magazine. It was an inspiration to advance my own vision of sequencing image and text. By using today's technology I realized I could bypass cultural gatekeepers and launch an art book to a connected audience.

Verve: vigor and spirit, an expression of life itself. It is a theme intertwined within this book. I enliven the title here as an homage to each artist who in his or her own way did so for the covers of the original magazine.

Artists consider the art they make to be expressions of what they think art should be in their time, and they want others to know. I intend this book to contribute to the ceaseless continuing discourse.

All the Living Things

Over the years, I have painted many landscapes. Doing so means looking hard at the view. It trains the eye and focuses the mind. Gazing and picturing are something like meditation. At times, after long sessions, the names of the things in my view seem to slip away, and the meanings are lost. When this happens, I believe I understand how all the other living creatures see the world. Ethereal phenomena—is it all created by the senses and the mind? Is it all soul stuff? Perhaps the trees, the sky, and the landscape are not as enduring as they appear. Pursuing these thoughts, I began an inquiry into the history of physics and ancient philosophies.

I discovered a deep affinity between these disciplines. I found texts that inspired my writing, which I present here, paired with paintings of nature and thoughts about the artmaking practice. A painting is a window of a particular kind. It is looking out as well as within—a reflection both of what the senses perceive of the world and the intuitive mind of the maker. I think the best paintings are not revealed by descriptions or criticism but by the experience of creating and seeing. I have re-worked an old Zen saying that I hope conveys this idea:

Before you begin a painting, mountains are mountains and rivers are rivers.

While you are painting, mountains are no longer mountains and rivers are no longer rivers.

But when you have finished a painting, mountains are again mountains and rivers rivers.

Jim Holl
Catskill, New York
March 12, 2016

The big bang from the perspective of a balloon

In the beginning, the universe was
 a one-dimensional point
 (very small, very dense, and without space)

The laws of physics as we know them were yet to operate.
 In an instant time and space began when this one-dimensional point
 became expanding-everythings-in-all-dimensions

 If the universe were a balloon
 the beginning of the blowing
 would be the
 big bang
 and all the expanding-everythings—
 planets, people, places, things—
 would expand across the balloon's surface

As each of these things is an emanation from that same one-dimensional
 point-that-became-expanding-everythings-in-all-dimensions
 each planet, each person, each place, and each thing is then
 the exact center of the universe

This means we are, each of us, the center of the universe—and also kinfolk!

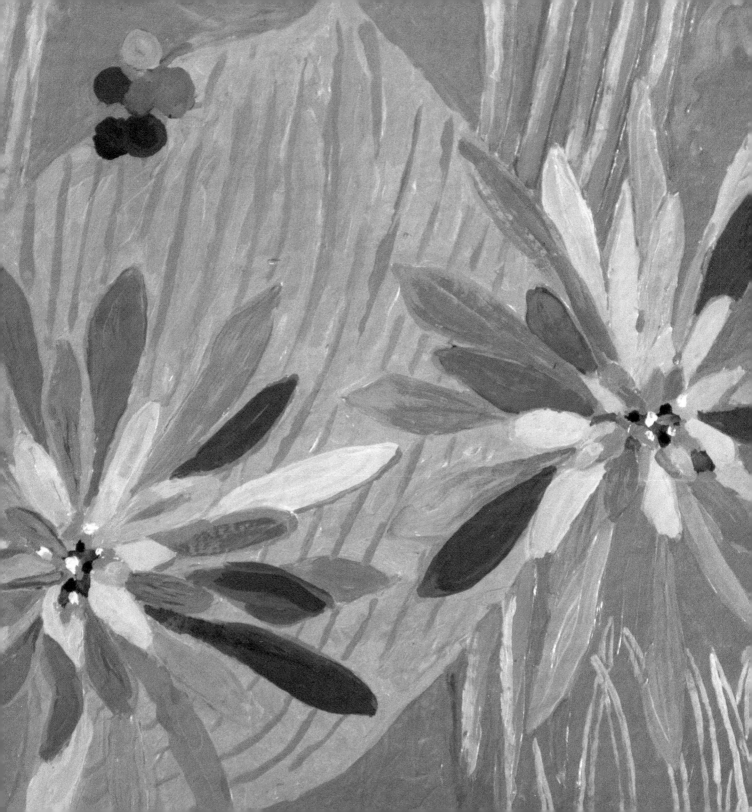

How small the universe

A Planck length is the smallest measure of the universe—
far smaller than what is technically measurable

If there is a thing smaller
it is meaningless
no up no down no future no past

before matter just a maybe
nothing to measure
just a possibility of what might become

It is:
that we cannot cross this threshold to
the other realm: smaller
than the smallest particle point

(if it exists) *it is:*
just the thought of the smallest thing

Max Planck imagined this length to be one of time as well—
if time or space is immeasurable

It is:
<0.000000000000000000000000000000000000001*

From this *thought* the universe emanates—and scale begins

Part two: a quantum bath

i. A hot tub is best at 104 degrees.

It is imperative that its water jets shoot vigorously.

The water should be bubbling, splashing up in squirts enthusiastically churning.

Lowering to eye-level with the surface roil creates the experience
of quantum foam.

ii. Every fundamental microscopic particle that makes up our universe is thought to
be an expression of energy emanating as a field. Besides the four "force" fields there are
the "matter" fields of particles. These fields animate our universe at a smoothly coherent
pace on our large macro scale.

iii. On a micro scale before these fields form,
at a millionth of a billionth of a billionth of a billionth of a centimeter
space and matter become a seething boiling cauldron of frenzied fluctuations

 back forth

 up down

 before after.
They lose meaning.

 Our conceptions of space and time no longer apply.

It is from this micro scale our universe radiates.

iv. While in the bath, may I suggest that in addition to experiencing quantum foam,
allow the all-over tingling of spirited hot bubbles to rouse a shortcut to nirvana.

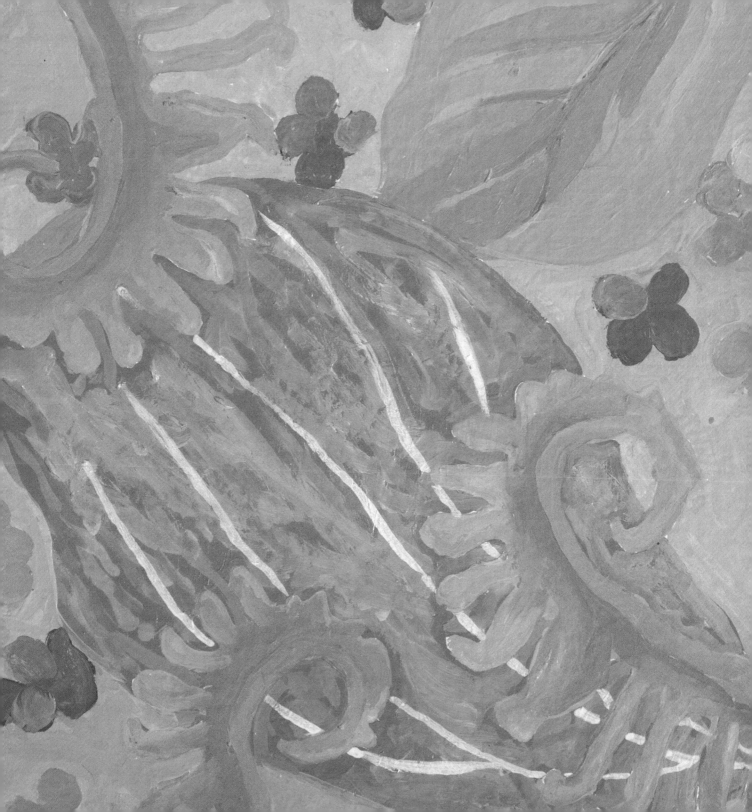

What direction the arrow of time

Examining the universe from very short distances over very brief times
 reveals it to be a frenetic place.

Its miniscule quantum particles are said to have no internal structure.
 Yet they still possess mass, spin, velocity.

According to the Uncertainly Principle these specks hover in indeterminacy.
Until measured, their attributes, including their place in space, have yet to appear.
 Like a blank canvas they are unrealized amorphous probabilities.

Only when detected by the senses does one outcome emerge from the many.

At the quantum scale, this means the past is realized only after the future
to which it leads has occurred. Here time goes both ways:
 the future determines the past.

On our scale the arrow mysteriously only goes forward.
A brush stroke for a painter is preserved as a measure of memory.

The brevity of the moment has passed before the stroke is at its end.
The receding traces are evidence of a consciousness once present.
 And by being in the moment the future never arrives.

"We are born and die seven thousand times in one second," said Buddhist monk T.M. Roshi.

Art is a contemplation of mortality; the grandest of gestures the mind can leave to time.

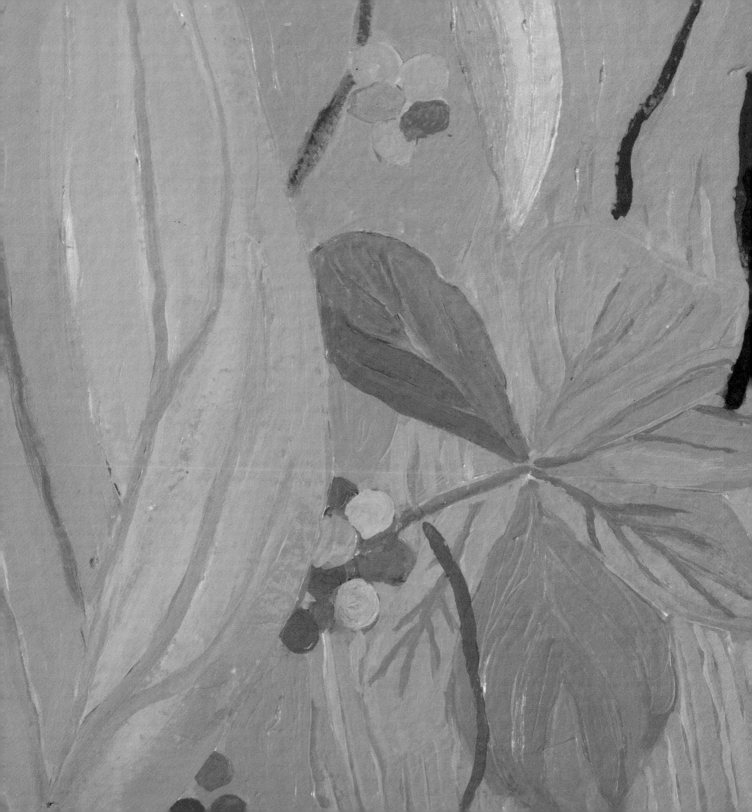

An unsolved mystery from the beginning of the mind

The progression of humankind's attention to the gross matter of the world:

Stone age >iron age >industrial age >electronic age >atomic age >quantum age.

In the industrial age, physicists thought up a theory to explain
the big and the heavy.

In the quantum age, they came up with another to explain
the fine and invisible.

But the theories of general relativity (the large) and quantum physics (the small) don't
agree
on how
energy loops >
protons >
neutrons >
quarks >
electrons >
atoms >
 billions of molecules
 make water and ice
 to become a glacier
 on Mount Rainier.
Nature just does it and we still don't know how.

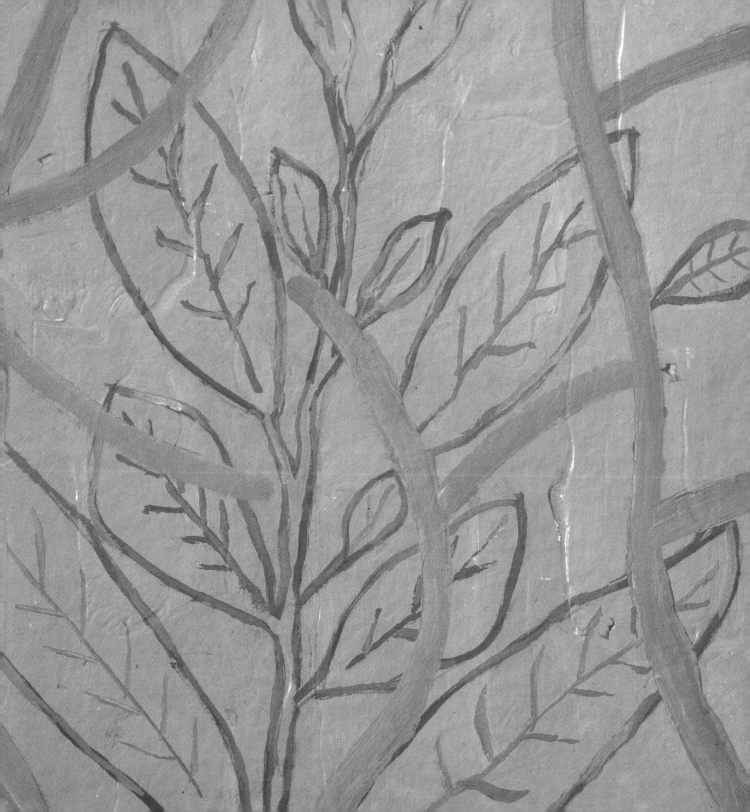

The double slit experiment

Early In the 19th century, the physicist Thomas Young presented an experiment that proved the world comes into existence by the attention the conscious mind gives to it. Niels Bohr's research confirmed his results. And mechanical experiments without human mediation did not change them.

The basic constituents of matter, the photons of light, are both
 entities like particles
 and nonentities like indeterminate waves

In their wave state, photons
 may not exist
 cannot be found

They are just a probability of becoming
 in the world

Only when the human mind detects the particle
(then and only then)
 does it snap into reality
 as a thing

All elementary particles that make up matter
 —photons, electrons—
 respond the same:

The subatomic world of which we are made
 does not occur until detected.

Poor Newton: his predictable world upturned!

But Einstein defended him, exclaiming:
 "Do you really believe that the moon is not there unless we are looking at it?"

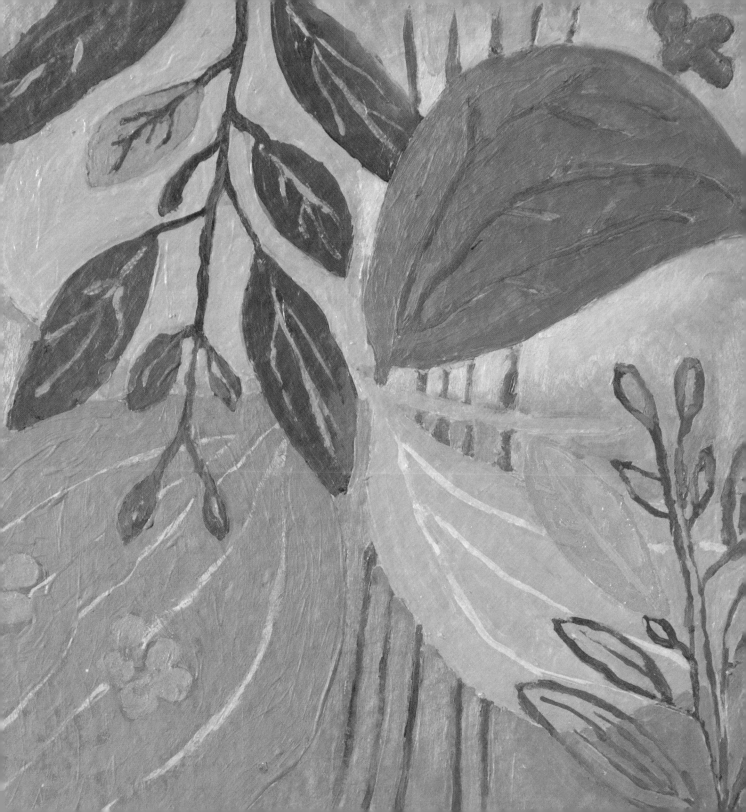

A koan physics found

What is both determinate like a pebble striking a beach
and indeterminate like a wave washing up on a shore?

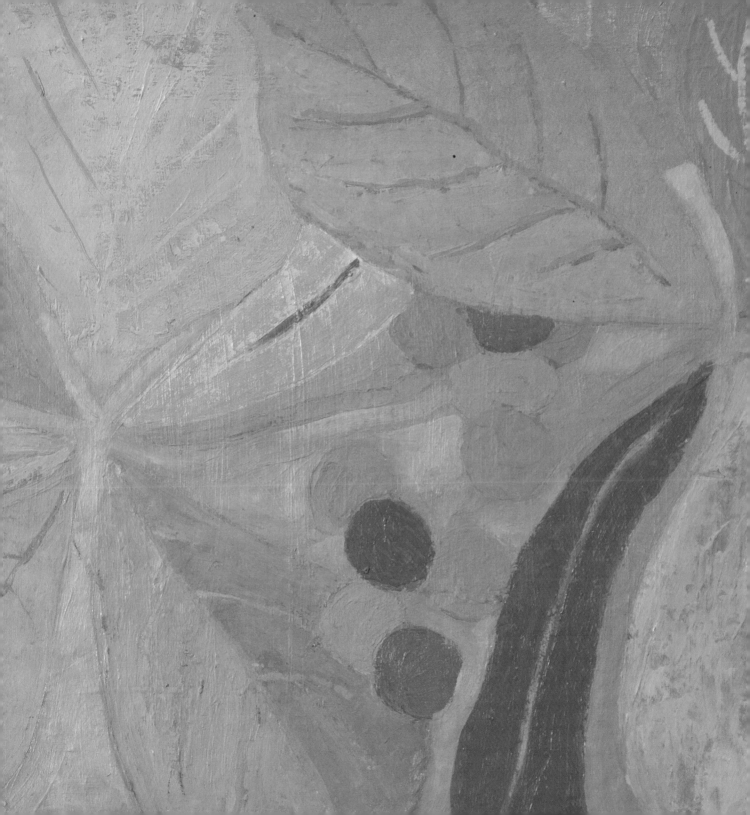

All theories change, the why remains

The mind makes up theories

Electrons and photon particles exist
only as traces.

Scientists can't see them but can measure the mark
they leave behind.

Other particles are hypothetical. They exist
to prove equations.

Physics says equations mirror phenomena.

(It took fifty years of looking to prove the equation that predicted the Higgs boson.)

Theorists postulated it was necessary that space
not be empty.

The mind of man made physics, a parallel universe of ideas describing how nature
works, but not why.

The why of nature remains as unanswered.

One thing art is good at is veneration; maybe that's enough.

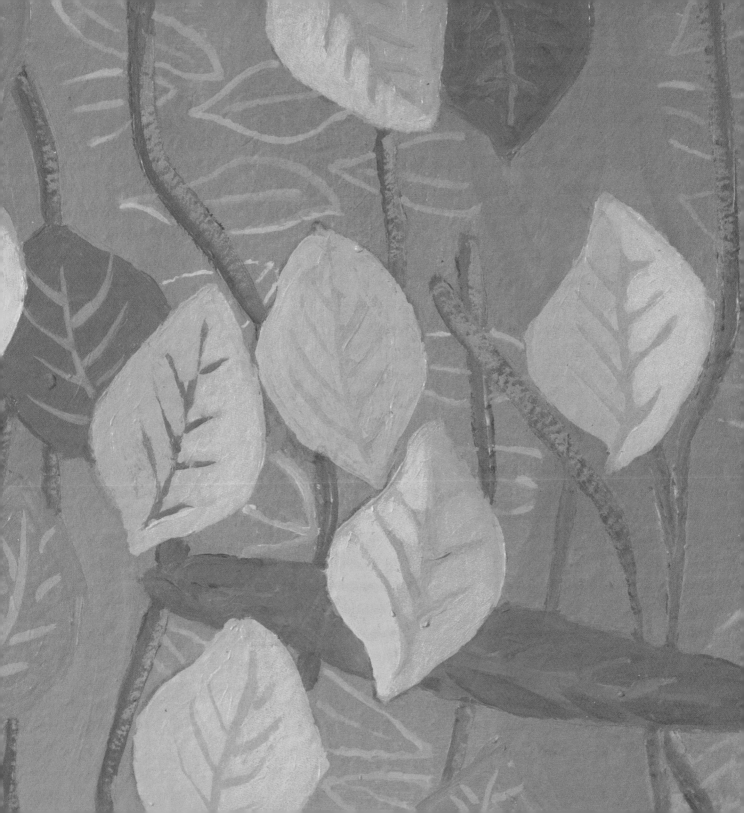

Non fui, fui, non sum, non curo

An Epicurean epitaph:

"I was not; I was; I am not; I do not care."

The Epicureans of ancient Greece thought the soul could only exist in the matter of the body and mind. At birth the soul spontaneously appeared only to vanish when matter died.

Nothing before, nothing after.

So no worries, enjoy the pleasures while you can.

The consciousness of being alive is a talent shared by the spectrum of souls embodied in matter. Many creatures think very well.

So where is the spirit before germination?

The belief that a conscious spirit exists in the universe un-embodied would, for the Epicureans, ruin a good time.

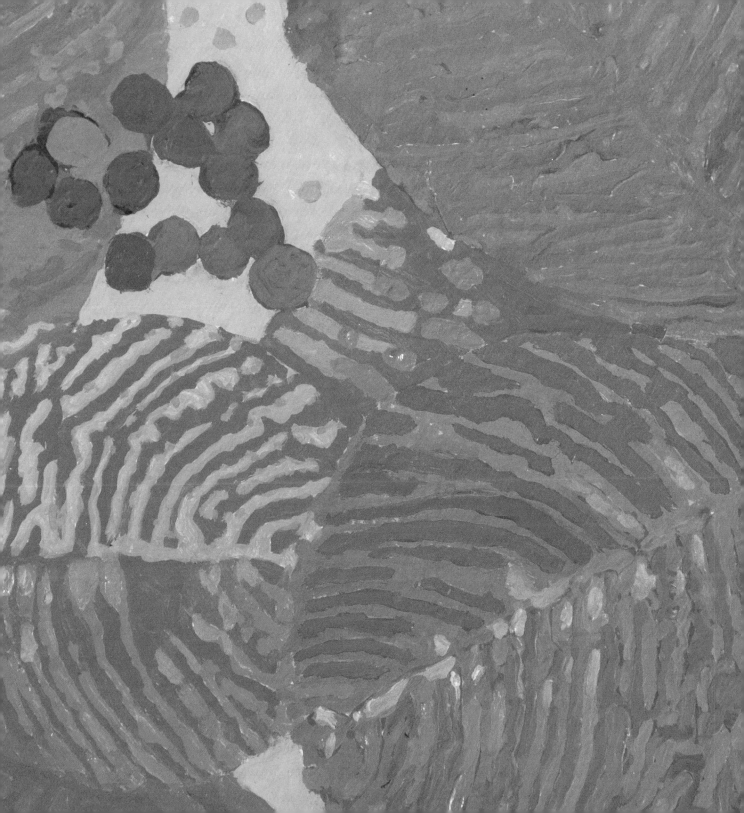

All is of one for matter is alive

Said the Greek hylozoists in 600 BC.

In 465 BC Democritus formulated a theory
 that the world was made of atoms
 the smallest
 expression of
 matter inert
 and indivisible:
 matter divided
 from life
 in the physical world

This dualism forecast the philosophies of the West
and inspired Aristotle to hypothesize that the universe
was made of fifty-five spheres:
 the outermost sphere, the ethereal spirit of heaven
 encircling the inert matter of earth encompassing
 the spheres of hell
 (and the fall of mankind)

The church liked this.
For Aristotle's mistake thousands burned at the stake.

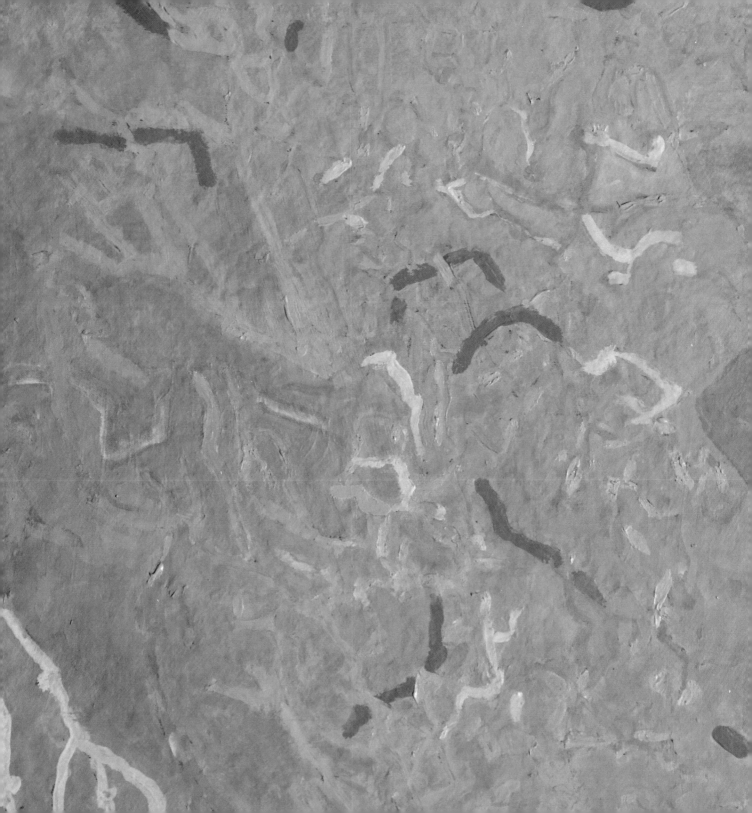

Paintings should look alive

All paintings are still-lifes, (actions that have stilled).

Einstein's famous equation shows us
mass and energy are interchangeable.

The Standard Model in physics tells us
the universe is made up of elementary particle points
 in perpetual motion.

String Theory says these particles are not discrete points
 but looping energies.

The artist transforms mental energy into media.
 The media elicits sensations in the viewer
 —this energy is felt.

Matter, the media is
 the vibrating transmitter of energy.

This mirroring of phenomena is a good reason still-lifes should look alive.

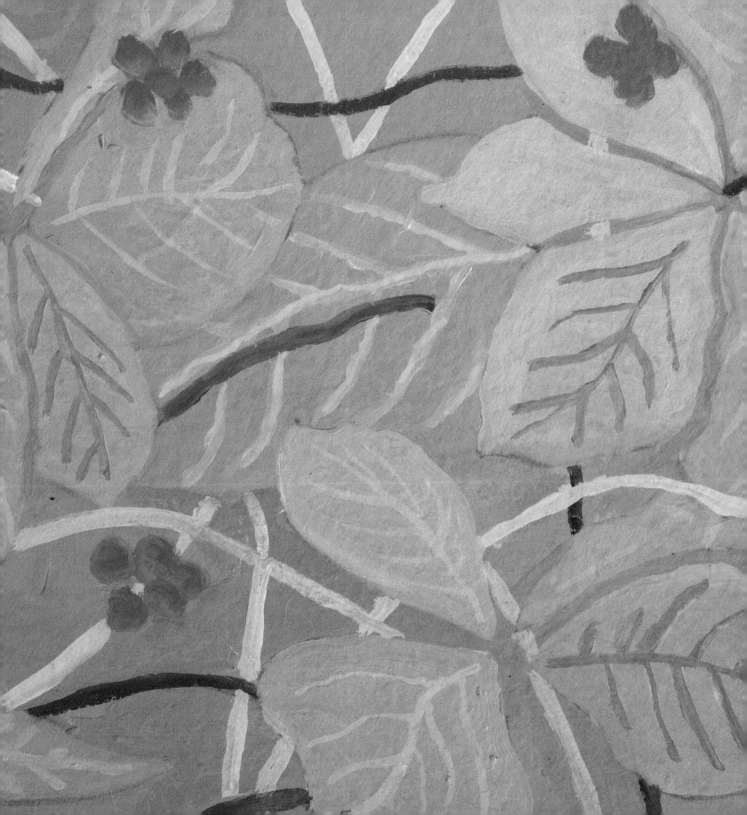

What is true for the universe is true for painting

In 1935, Einstein and other physicists set out to prove that microscopic particles in their state of indeterminacy have separate measurable properties. This meant that whatever an object over there was doing had no relation to what an object over here was up to. If it were true it would show the universe to have laws that are local, discrete. Their hypothesis was proved wrong. When the "entangled" particles were measured, no matter how far away they traveled from one another, they exhibited the exact same properties. It was as if one was giving the other instructions that traveled faster than the speed of light. Which is impossible. Not happy, Einstein called this repudiation of "locality," a principle of the Newtonian Standard Model of physics, "spooky action."

Through empirical measurement, this experiment showed that the universe is rooted in reciprocity; the interdependency of phenomena is no longer a metaphysical postulation. The concept of transcendent physical matter, long held by ancient Eastern philosophies, is now confirmed by contemporary Western science.

What is true for the universe, I believe, also holds true for painting:. All elements should be considered equally, negative space is an oxymoron. As an homage to the universe, this interdependency of form, medium, and content should aspire to be more than its parts: a balanced and subtle intention.

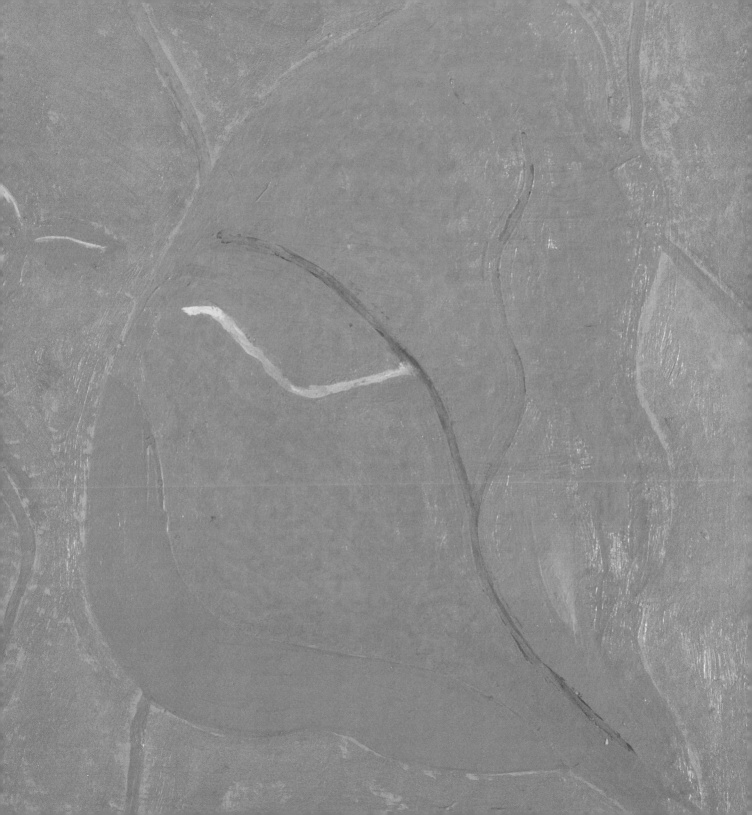

All of the "All Mighties"

Adapting Democritus' theory of atomism the Epicureans professed that atoms whooshed through the void and by their swerving and bumping into one another all of the matter of the world was made.

It wasn't until the 19th century that atoms were determined to be divisible into electrons, protons, and neutrons. In the 1960's quarks were determined to be an even more fundamental particle existing within the atom. Having no internal structure these and other particles were said to be the underpinning of matter, until String Theory was invented in the mid-1960's.

String Theory is said to have the potential to unite physics' great macro and micro schism, and make the theoretical world one. String Theory simply asserts that elemental matter is not a particle point but a loop of undulating energy. By the variety of the strings' vibrations, all of the particles that assemble all of the atoms create the universe.

It gets complicated. To make the theory work it requires 10 dimensions. Imagine a miniscule looping string of energy blown up to become a dimension in addition to the four we are aware of. This dimension could be the entire universe—a gigantic looping manifestation of a string—that would make five strings out of ten. As a gigantic closed string, the universe would be infinite: traveling to the end would loop one back to the beginning. If this were true only Pantheism would be plausible: nothing "other" or outside of nature, no abstractions between sunrises. All thoughts of the "All Mighties" would be synonymous with Infinite nature.

So it's easy to see God. All you have to do is go outside.

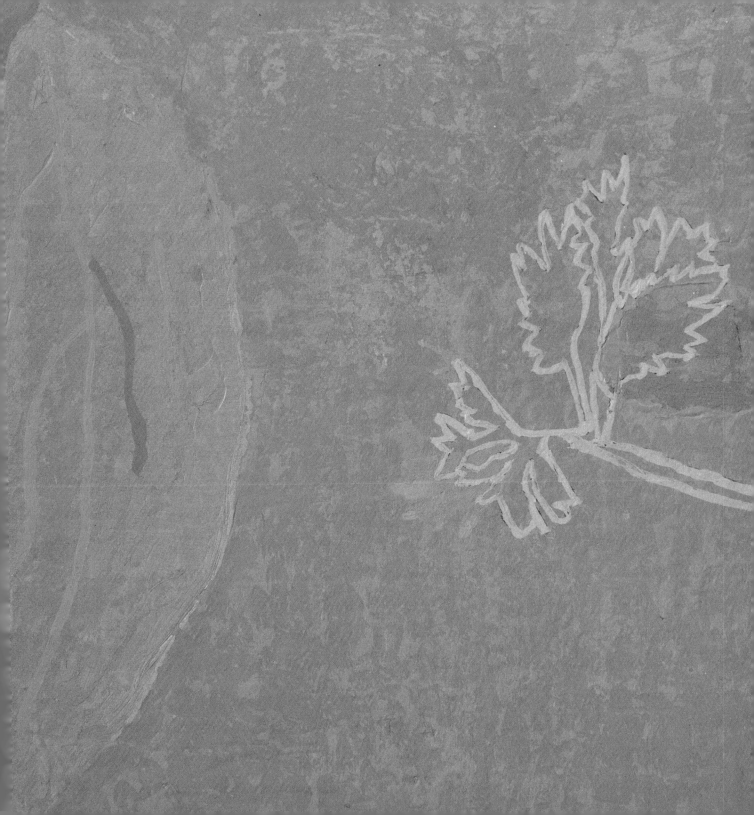

Formless thoughts

It was all hydrogen and helium
in the beginning.
>That was it.
Extreme energy transmuted these atoms into the ninety-two that make up
>the universe we know.
Just as temperature transmutes water to steam or ice
>new matter is made through transmutation.
Exploding stars dispersed all of the atoms across the sky to create all that is.
The cause: energy. The effect: transmutation of one form of matter into another.
>Except in the brain.
In the brain, energy is passed from one neuron to another and the result
is not a transmutation into new matter
>>but consciousness
>matter transmutes into something extraordinarily formless:
>an idea.
>Synapse!

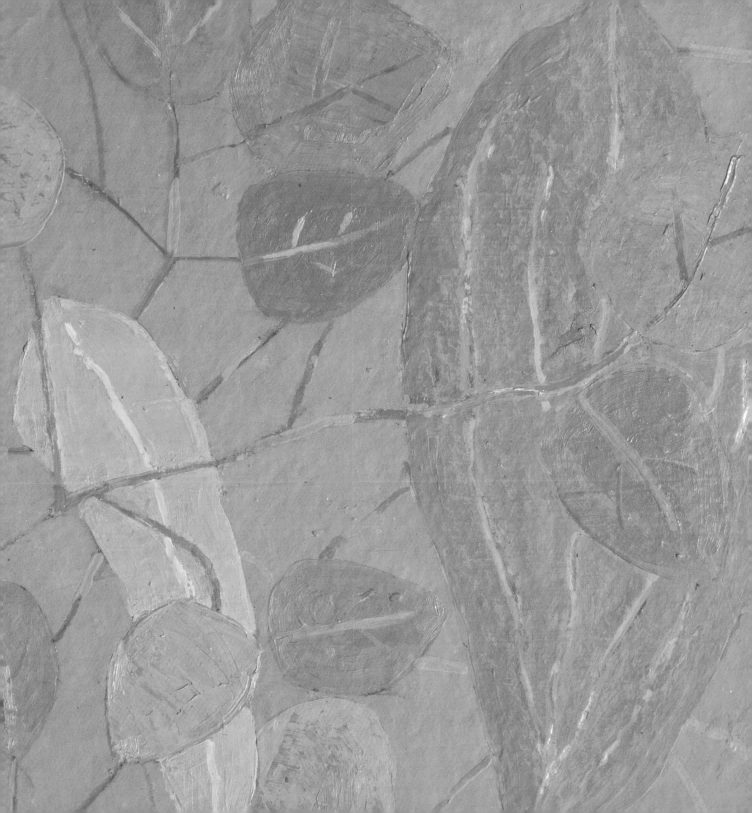

What makes rocks hard

Science invented a microscope that can see atoms.

I've seen photos:

 Atoms align
 little balls in patterns
 different patterns
 for different things
 —spoons, saucers, everything
 atoms bunched up
 atoms made up
 of very small indeterminately
 whizzing electrons around
 a very much smaller nucleus of protons and neutrons
 600 miles a second
 the tighter they're packed
 the faster they move
 the faster they move
 the more rigid the surface
 of the atom.

Mount Rainier, an immense rock of immeasurable weight at least 500,000 years old, vibrates, ripples, and trembles with great velocity.

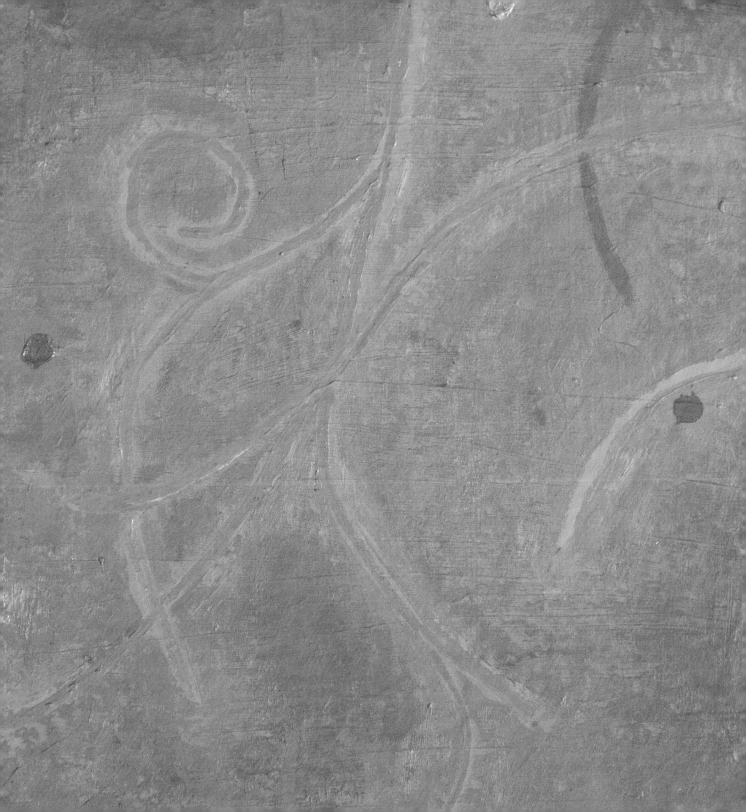

An ancient Hindu metaphor of the universe

Indra's jeweled net reaches out to infinite space. At each knot on the net is a crystal gem, which is connected to all the other gems and reflects in itself all the others.

On such a net, no jewel is at the center or the edge.

Each and every jewel is at the center in that it reflects all the other jewels on the net.

At the same time, each and every jewel is at the edge in that they are themselves reflected in all the other jewels.

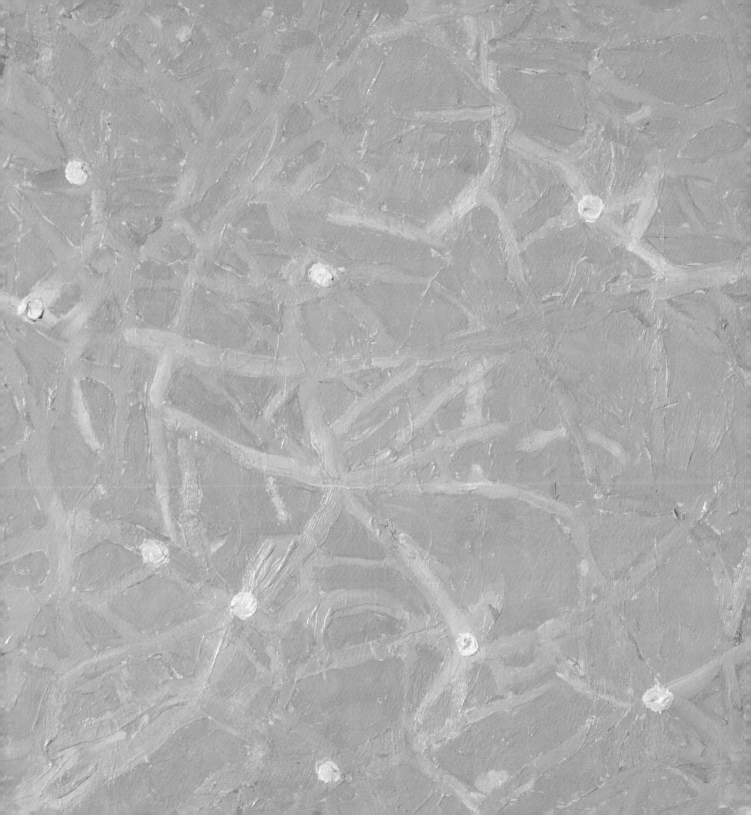

The soul is and it is mighty small

The Bhagavad-Gîtã identifies the dimension of the soul:
"The upper point of a hair divided into one hundred parts and again each of such
parts is further divided into one hundred parts, each such part is the measurement of
the dimension of the soul. "

The soul is
but cannot be found
in dogs, cats, fish, frogs, spiders in their web, or us

Yet the soul is within
the body of an elephant
and in the big banyan tree
and as well
in all the bacteria in a drop of water

Look for it

You can find it in the leaves.
It gives everything color

Proof of this is a dead thing

Science studies only the matter of the universe

So it cannot find the soul
because it has exactly the set of properties
it should have if it didn't exist.

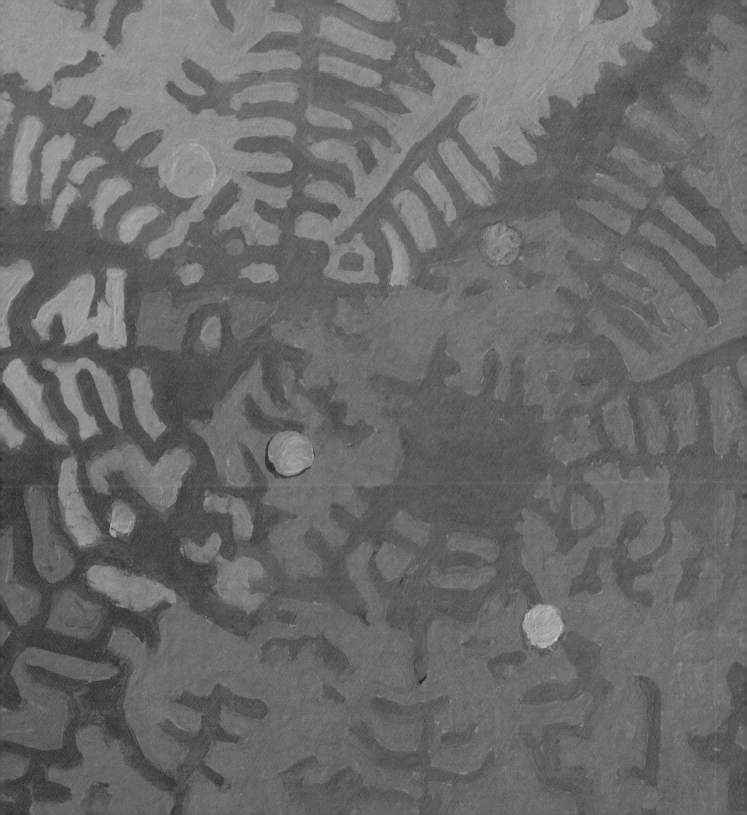

Jesus walks on water, yogis walk on fire

Energy and mass transpose.

The Law of Conservation:
 energy cannot be created or destroyed
 but only change—one form
 to another

 the total amount of energy remains
 constant

 our primordial universe appears as encompassing fields of energy bounding
 particle points into atoms that become
 everything else.

Swami Yogananda's Law of Miracles:
 beings of transcendent intuitive consciousness
 can materialize
 and dematerialize
 bodies of mass
into energy. Beings are able
 to fulfill the condition of consciousness
 no longer bound
 by mass.

 Consciousness can be free from the gray matter of the mind.
 Said the Swami.

I read a story of a yogi who could conjure the scent of flowers from the palms
of his hands.
 Self-knowledge, a kind of miracle.

Brains in space, we are not alone

Ludwig Boltzmann, one the founders of the field of thermodynamics, asserted that nature tends toward chaos. If entropy is the norm, order is an oddity, a random fluctuation. An exceptional example of order is where conscious thoughts coalesce in our highly organized body.

In the universe where chaos is more common, disembodied thoughts would be more likely to occur. Pure thought being immaterial.

Boltzmann described a theory of a universe where consciousness floats free in space, emerging randomly. This phenomenon is now known as Boltzmann's brains.

I once made sculptures of brains floating in space to suggest spirits thinking. It wasn't theoretical.

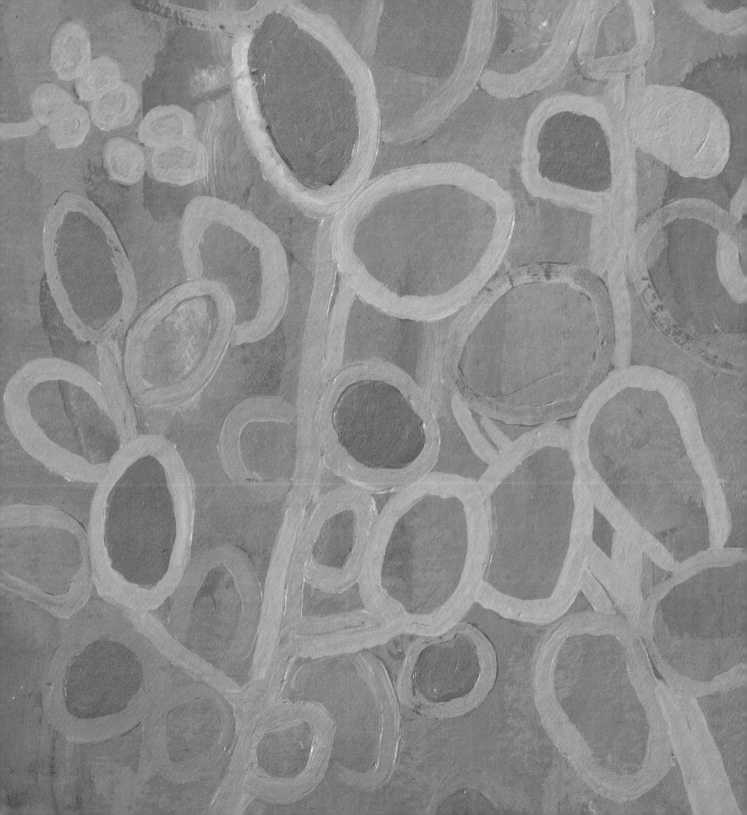

What color is

I believe a painting in a room emanates a mood a viewer can feel.

Color best expresses this tonal mood. Composition, scale, gesture, media and surface play supportive roles.

Music is analogous to color. Both are vibrations capable of conveying emotions.

Vibrations are the essence of the spirit soul. To vibrate is to live. Like a finger print everyone has a unique vibrating tone.

Feeling this quiver when gazing upon a painting gives rise to an affinity with one's own melody.

This is a definition of quality.

Where. . . the meaning of life

In nature all energy spirals
galaxies swirl, planets orbit, tornados twist
and electrons spin around the core of atoms.
I have read that there are seven cycles of energy in the human body
and these coiling life forces align up the spine.
I asked my doctor about chakras and he said they didn't exist.
 Science couldn't find them.

I've read in the bible that "Moses lifted up the serpent in the wilderness."
Swami Yogananda said the seven seals described in Revelations are the chakras.
To raise the energy of the chakras from the tailbone up to the crown of the head may
take a lifetime, but to do so reveals to oneself the meaning of life.
 So I've read.

I created an art installation once; dark down behind a boiler, across a stage, the
beholders bent over to view what between their legs were twisting serpents rising
from where energy and light came.

I called the show *When Creatures Crawled From the Bowels of the Earth*.

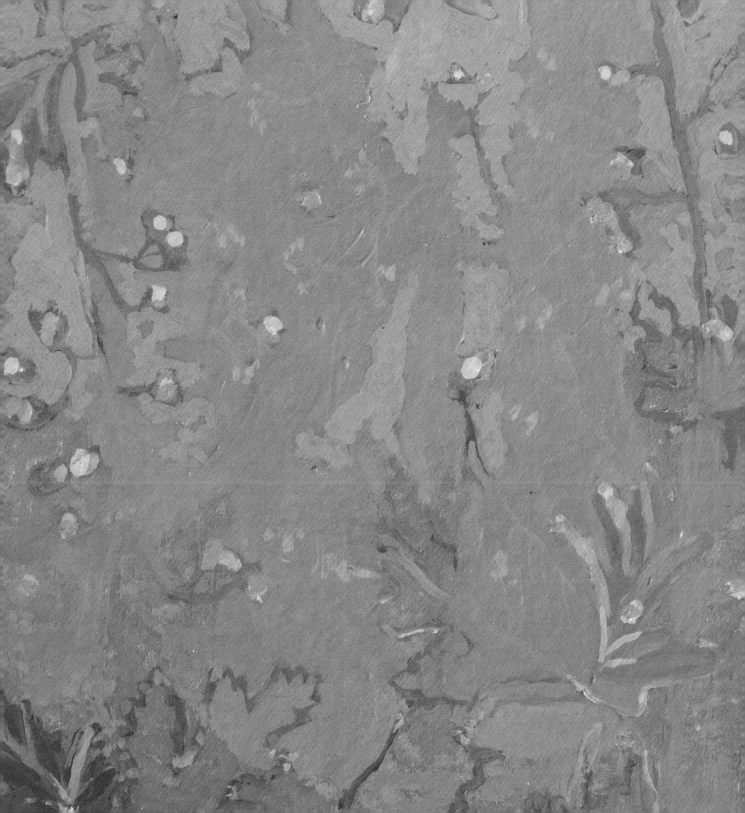

Painting dancing matter

Subatomic particles are waves and energies. Each produces a rhythmic pattern akin to sound.

"All things are aggregations of atoms that dance and by their movements produce sounds." Said a Tibetan Buddhist long ago.

And when the song changes matter is made anew.

The ancient Hindu God Shiva is the dancing deity of cosmic life. Posed in a pirouette, she holds from outstretched arms the nature of matter: all creation and destruction, balanced upon the tribulations of mankind occurring within.

By smashing matter together, science recently found Shiva in a particle accelerator.

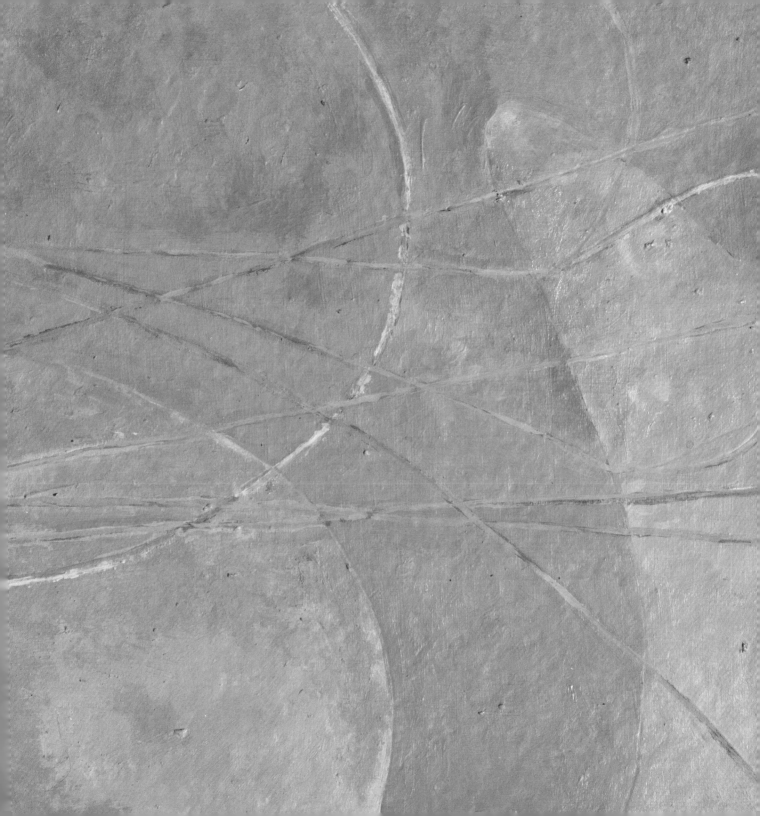

All are on a precipice

Science says the primary properties of the universe were instilled
 at the moment of the big bang.
Pythagoras said the universe is based on numbers.
There are six, science found, that correlate to its equilibrium.
 And the tuning is precise.

One of those numbers defines how all the atoms were made. Its value is 0.007. If it was 0.006, we and atoms would not exist.

Another is huge: a one followed by 32 zeros. It corresponds to gravity. If one or two of the zeros did not exist, gravity would be so strong people would be very short with legs like tree trunks. It would be hard to breathe, slow to move, and everything would be very heavy.

A self-evident number has been known since the advent of awareness. It is three: the number of spatial dimensions in our world. If it were two we wouldn't be.

It could be that it was lucky chance it happened to fall exactly on these six in a row—
 or it could be providence.

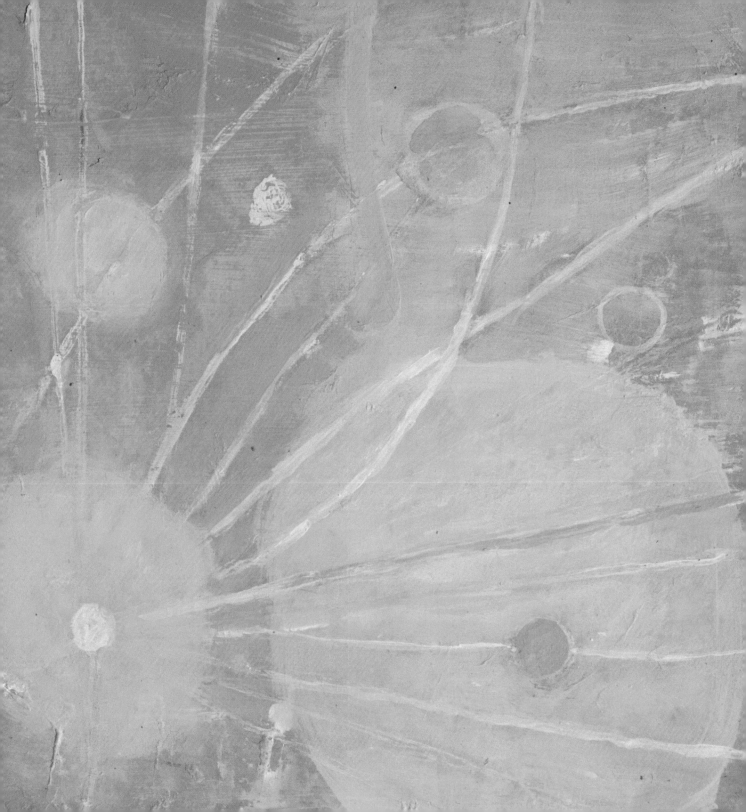

After all this, it was the wrong paradigm

What is the essence, the smallest indivisible thing of matter that makes up the universe? This question has been asked since antiquity.

Finally scientists built a particle accelerator to find out:
seventeen miles in circumference to break apart the smallest
atomic particles at the greatest possible speed.

They found out that particles do not deconstruct into more elementary matter.

They mutate.

Particles are energy and vanish into energy.
Each transmutable into another.

Scientists found matter is a continual apex of becoming—all creation and destruction,
like bubbles about to burst—all transforming interrelated patterns of energy,
for all time.

As the Dalai Lama explains:
"All things and events, whether material, mental, or even abstract concepts like time,
are devoid of objective independent existence."

Our awareness of this shared quintessence inspires us to care for all the living things,
even the creatures that crawl. And to respect the stones on the ground, for they have
a lot more time before they mutate into something else.

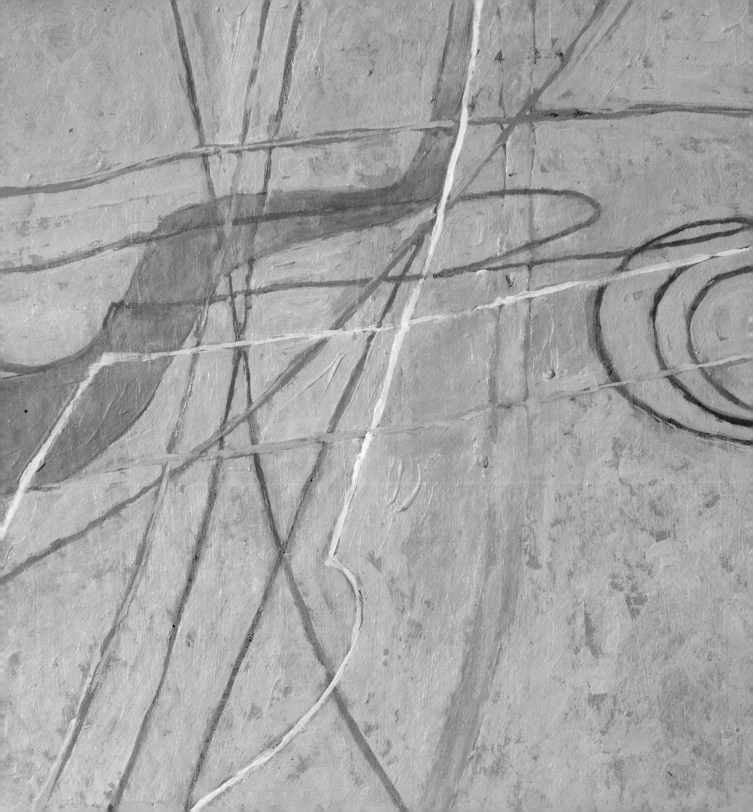

READING LIST

Beardsley, Monroe C. *Aesthetics from Classical Greece to the Present*, Tuscaloosa, AL: The University of Alabama Press, 1975.

Capra, Fritjof. *Tao of Physics*, Boston, Mass: Shambhala, 2010.

David-Neel, Yongden, Lama. *The Secret Oral Teachings In Tibetan Buddhist Sects*, San Francisco, CA: City Lights Books, 1967.

Dorsky, Nathaniel. *Devotional Cinema*, Berkeley, California: Tuumba Press, 2005.

Emerson, Ralph Waldo. *Selected Essays, Lectures and Poems*, New York, NY: Bantam Books, 2007.

Frankel, Viktor E. *Man's Search for Meaning*, New York, NY: Washington Square Press, 1984.

Greenblatt, Stephen. *The Swerve*, New York, NY: W.W. Norton, 2011.

Gao, Shan, *Quantum Reality: A Short Journey Through Two Slits*, Amazon Kindle, 2012.

Greene, Brian. *The Fabric of the Cosmos*, New York, NY: Vintage Books, 2005.

Greene, Brian. *The Elegant Universe*, New York, NY: W.W. Norton, 2003.

Larson, Kay. *Where the Heart Beats*, New York, NY: The Penguin Press, 2012.

Lama, Dalai. *The Universe in a Single Atom*, New York, NY: Three Rivers Press, 2005.

Lama, Dalai; Cutler, Howard C. M.D. *The Art of Happiness*, New York, NY: Riverhead Books, 1998.

Lucretius. *On the Nature of Things*, Arlington, Virginia: Richer Resources Publications, 2010.

O'Keefe, Tim. *Epicureanism*, Berkeley, California: University of California Press, 2005.

Paramahansa, Yogananda. *Autobiography of a Yogi*, Los Angeles, California: Self-Realization Fellowship, 2005.

Paramahansa, Yogananda. *Man's Eternal Quest*, Los Angleles, California: Self-Realization Fellowship, 2008.

Prabhupadā, A.C. Bhaktivedanta Swami. *Bhagavad Gitā*, Los Angles, California: The Bhaktivedanta Book Trust, 1983.

Rees, Martin. *Just Six Numbers*, New York, NY: Basic Books, 1999.

Revel, Jean-Francois, Ricard, Matthieu. *The Monk and the Philosopher*, New York, NY: Schocken Books, 1998.

Ricard, Matthieu, Thuan, Trinh Xuan, *The Quantum and the Lotus*, New York, NY: Three Rivers Press, 2001.

Rinpoche, Sogyal. *The Tibetan Book of Living and Dying*, New York, NY: Harper Collins, 2002.

Roshi, Taizen Maezumi. *Appreciate Your Life*, Boston, Mass.: Shambhala, 2001.

Rosenblum, Bruce, Kuttner, Fred. *Quantum Enigma*, New York, NY: Oxford University Press, 2011.

Suzuki, D.T. *Essays in Zen Buddhism*, New York, NY: Grove Press, 1984.

Thurman, Robert. *Inner Revolution*, New York, NY: Riverhead Books, 1999.

Yukteswar, Swami Sri, *The Holy Science*, Los Angleles, California: Self-Realization Fellowship, 2013.

IMAGE LIST

7. *All the Living Things: Olympic Wildflower, 7.1.15,* oil on Shikishi Kochi handmade paper, 9.5 x 9.5 in.

9. *All the Living Things: Pacific Red Elder (close up), 7.15.15,* oil on Shikishi Kochi handmade paper, 9.5 x 9.5 in.

11. *All the Living Things: Fiddlehead Fern, 10.1.15,* oil on Shikishi Kochi handmade paper, 9.5 x 9.5 in.

13. *All the Living Things: Bunchberry Dogwood,10.15.15,* oil on Shikishi Kochi handmade paper, 9.5 x 9.5 in.

15. *All the Living Things: Aluminium, 9.15.15,* oil on Shikishi Kochi handmade paper, 9.5 x 9.5 in.

17. *All the Living Things: Bitter Cherry, 8.1.15,* oil on Shikishi Kochi handmade paper, 9.5 x 9.5 in.

19. *All the Living Things: Bunchberry Dogwood, 8.15.15,* oil on Shikishi Kochi handmade paper, 9.5 x 9.5 in.

21. *All the Living Things: Cherry Leaves, 9.1.15,* oil on Shikishi Kochi handmade paper, 9.5 x 9.5 in.

23. *All the Living Things: Skunk Cabbage, 11.1.15,* oil on Shikishi Kochi handmade paper, 9.5 x 9.5 in.

25. *All the Living Things: Wisteria, 1.1.16,* oil on Shikishi Kochi handmade paper, 9.5 x 9.5 in.

27. *All the Living Things: Beech Tree, 12.1.15,* oil on Shikishi Kochi handmade paper, 9.5 x 9.5 in.

29. *All the Living Things: Biltmore Carrionflower, 12.15.15,* oil on Shikishi Kochi handmade paper, 9.5 x 9.5 in.

31. *All the Living Things: Eastern Figwort, 3.1.16,* oil on Shikishi Kochi handmade paper, 9.5 x 9.5 in.

33. *All the Living Things: Catalpa, 2.1.16,* oil on Shikishi Kochi handmade paper, 9.5 x 9.5 in.

35. *All the Living Things: After a Pion-Proton Collision , 2.15.16,* oil on Shikishi Kochi handmade paper, 9.5 x 9.5 in.

37. *All the Living Things: Bramble, 3.15.16,* oil on Shikishi Kochi handmade paper, 9.5 x 9.5 in.

39. *All the Living Things: Maidenhair Fern, 4.1.16,* oil on Shikishi Kochi handmade paper, 9.5 x 9.5 in.

41. *All the Living Things: Maple, 4.15.16,* oil on Shikishi Kochi handmade paper, 9.5 x 9.5 in.

43. *All the Living Things: Yerba Buena, 5.1.16,* oil on Shikishi Kochi handmade paper, 9.5 x 9.5 in.

45. *All the Living Things: Honeysuckle, 5.15.16,* oil on Shikishi Kochi handmade paper, 9.5 x 9.5 in.

47. *All the Living Things: Ivy, 6.1.16,* oil on Shikishi Kochi handmade paper, 9.5 x 9.5 in.

49. *All the Living Things: Collision of Pions, 6.15.16,* oil on Shikishi Kochi handmade paper, 9.5 x 9.5 in.

51. *All the Living Things: Photon Collisions, 6.1.17,* oil on Shikishi Kochi handmade paper, 9.5 x 9.5 in.

53. *All the Living Things: Electron Positron Passings, 7.5.16,* oil on Shikishi Kochi handmade paper, 9.5 x 9.5 in.

Cover. *All the Living Things: Particle Shower, 7.15.16,* oil on Shikishi Kochi handmade paper, 9.5 x 9.5 in.

About The Artist

The artwork of Jim Holl has been widely exhibited and collected. He has mounted solo and group exhibitions with public institutions such as The New Museum, PS1 Museum, Creative Time, The Seattle Art Museum, Samuel Dorsky Museum of Art, and Artists Space in New York. Additional selected exhibitions include 'T' Space, Rhinebeck, New York; Prographica/KPR Gallery, Seattle, WA; Architecture for Art Gallery, Hillsdale, New York; Philadelphia Art Alliance, PA; The Arts Center Gallery, Saratoga Springs, NY; Terenchin Gallery, NY; The Catskill Mountain Foundation, NY; BCB Gallery, Hudson, NY; Thompson Giroux Gallery, Chatham, NY; Denise Bibro Gallery, NY; and the Byrdcliffe Kleinart/James Center for the Arts, Woodstock, NY.

Jim Holl established James Holl Design in 1981. JHD has served corprate and non-profit clients designing and producing print and web projects. Selected clients include Adidas, AT&T, Chase Manhattan Bank, Credit Suisse, Brooklyn Children's Museum, Doubleday, Emerson College, Houghton/Mifflin, Knoll International, March of Dimes, Marymount Manhattan College, Metropolitan Transit Authority, McGraw Hill, NYNEX, Newsweek, Random House, Scholastic Magazine, Sloan Kettering Memorial Cancer Center, 'T' Space and The Asia Society.

Jim Holl holds a BA from the University of Washington, an MFA from Columbia University. He is an Associate Professor of Art at Marymount Manhattan College in New York City, where he directs the Graphic Design program. Jim Holl's art is driven by themes that are manifested in sculpture, painting, photography, video and performance. He maintains studios in New York City, Catskill, New York and Manchester, Washington. Charta Art Books published Jim Holl's first book T*he Landscape Painter, an autobiography 1974 through 1994*. The book reflects on Holl's artistic journey against a background of two decades of art events and theories in New York City. More of Holl's work can be viewed on his website www.jimholl.com. Holl's work can also seen at Prographica/KDR Gallery in Seattle, Fox Gallery in New York City and Cross Contemporary Art in Saugerties, New York.

Acknowledgments

Jim Holl wishes to thank those who made this art book project possible:

Susan Wides for her unwavering support and devotion,

Marietta Abrams Brill for her clarity of mind and editorial excellence,

Bonnie Marranca for her critical eye at the last minute, and

Gail Wides for her generosity and honest critiques.

Special thanks to **Joy Harris, Michael Brod** and **George Quasha** for their kind support and advice.

'T' Space
EDITIONS

http://tspacerhinebeck.org/artist-editions-publications

Published in 2017. All rights reserved. No portion of this book may be appropriated without written approval of Jim Holl.

Email: jimholl.com@gmail.com

Web: jimholl.com

Designer: James Holl Design

ISBN: 978-0-692-95179-8

CPSIA information can be obtained at www.ICGtesting.com
Printed in the USA
LVIW01n1011121117
555986LV00025B/193